Edvard Munch

Frank Høifødt

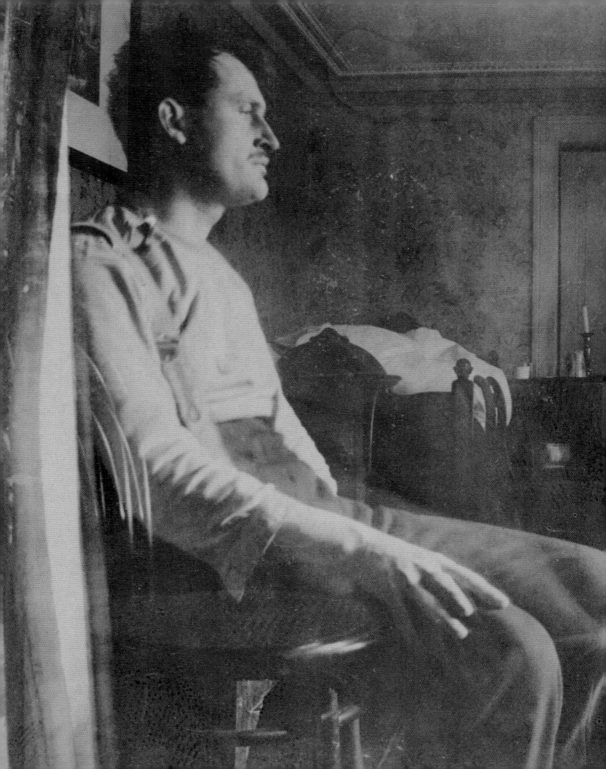

In the early 1950s, a decade after Edvard Munch's death, the Austrian expressionist Oskar Kokoschka made an attempt to open the minds of the British to the unrestrained and self-confessional art of this exceptional Norwegian: 'Expressionism is materialised experience, with the ability as such to communicate, a message from an I to a fellow human being.'[1] At the beginning of his career, Munch was synonymous with scandal, lending him the aura of a typical avant-garde artist. During the turn of the century and the turbulent transition to modernity, he passionately pursued his non-conformist ideals, influencing the course of art history with his images of the modern life of the soul.

It has proved hard to separate Munch from the myth.[2] No wonder, since the artist himself created a compelling legend in images and texts, a grand narrative of his life and his quest for meaning. Through his impressive output, he created a poetic universe of ideals, longings and terror, complete with aphorisms and retrospective clarifications. Hard facts blend with semi-biography and pure invention, creating a 'Poem of Life, Love and Death'.[3] When we appreciate his art – with a *willing suspension of disbelief* – we identify with the artist in his all-too-human story of love and despair. We share his predicament and his complex inner world. His art is not private, and should not be reduced to biography. *The Scream* (fig.28) is not a self-portrait; *Death in the Sickroom* (fig.30) is more than a family record.

To many people, Edvard Munch is synonymous with *The Scream*, one of the most famous images in the history of art. This dominant focus on his early work in the 1890s might suggest he died young. Far from it; Munch's artistic life spanned more than six decades, from the heyday of impressionism to Jackson Pollock's first one-man show.

In a modernist narrative, a substantial part of Munch's imagery might be judged as inferior, as literary art. 'How then does his

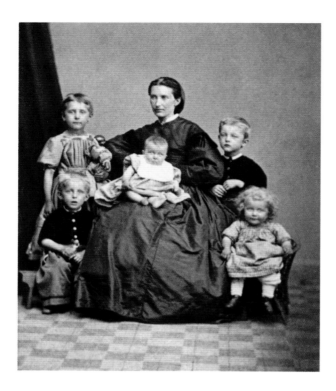

2. Laura Cathrine Munch with her five children (Edvard standing on the right), Autumn 1868 Munch Museum

illustration manage to carry so strongly and convey so intensely?' the American critic Clement Greenberg asked himself, puzzled by his own fascination.[4]

Background and childhood

'Illness, Insanity and Death were the black angels that stood by my cradle.'[5] This is Munch's poetic take on his childhood, expressing the artist's adult persona. Born in rural Løten in 1863, Edvard was named after his paternal grandfather, archdeacon and Court chaplain. There were several clergymen in the family, including a bishop, and his father, Christian Munch, was an army physician. The artist's mother, twenty years her husband's junior, was the delicate and tubercular Laura Cathrine.

At the age of one, Edvard moved with his parents and his older sister Sofie to Christiania (renamed Oslo in 1925). Here the family grew with the addition of three more children and Aunt Karen

Bjølstad, who had moved into the family's home to help because Munch's mother was waning from consumption. In December 1868, the whole family celebrated Christmas, but a few days later Laura Cathrine died (fig.2). Aunt Karen remained in her role as a substitute mother, becoming an invaluable and unflinching supporter of her artistically gifted nephew.

In 1875, the family moved to Grünerløkka, a suburb on the east side of town and on the 'wrong' side of the Akerselva River, the symbolic class divider.[6] Here, Edvard's delicate health was a constant issue and he was soon suffering from tubercular attacks. He was prayed for in church and recovered, but his older sister Sofie was not so fortunate, and died in November 1877.

The young artist
Munch resented the 'over-pietistic' spirit that reigned while he grew up.[7] The 1870s and 1880s were years of tension in the Norwegian capital as the modern breakthrough challenged Church authority. Not yet seventeen, Munch decided to become a painter, and registered at the Royal School of Design. In 1882, while renting a studio with friends, he was instructed by the radical realist Christian Krohg. Munch's earliest paintings, mainly landscapes and portraits, are competent specimens of realism and naturalism, the prevailing genres at the time. In the second half of the 1880s, expression and mood came to the fore, in keeping with a new romantic trend. Munch's first works shown at the newly established *Autumn Exhibition* were depictions of humble young women from the working classes, in the style and spirit of his mentor, such as *Morning* (fig.20). Krohg also promoted the symbolists Arnold Böcklin and Max Klinger, who influenced Munch; the former with his re-enchantment of the world, the latter with his graphic series tackling the subjects of love and death.

Following a trip to Antwerp and Paris in the summer of 1885, Munch embarked on a pivotal work, *The Sick Child* (fig.21). A conventional subject (with a private reference), a young girl dying of tuberculosis, was given a radical and experimental form. Hazy and dissolved, through layers of paint, the motif emerges like a vision or a subjective memory, in keeping with one of Munch's oft-quoted aphorisms: 'I paint not what I see but what I saw.'[8] This innovative

work was a provocation to the critics and a conservative public, and denounced as unfinished. Munch's role as *enfant terrible* was soon established. At this time, he also met his first love, a married woman who inspired romantic mythologizing and literary demonising in his quasi-biographical texts, referred to as 'Mrs Heiberg'.

Munch's devoutly religious home environment had been replaced with an anti-bourgeois bohemia. He admired the uncompromising leader of the Christiania Bohemia, Hans Jæger, although his own role in the group was largely that of a reserved observer.[9] With Édouard Manet and his champion Émile Zola as distant models, Munch was influenced by the bohemian command to 'write thine own life' and was soon at work on an illustrated diary. Over the course of his life, these highly miscellaneous jottings grew into a substantial and fascinating body of work.[10]

1889 – French connection

At the age of twenty-five, Munch applied for a scholarship to complete his training in Paris. He exhibited more than sixty paintings in his first one-man-show, including a scrutinising portrait of Hans Jæger, the crystalline and complex *Music on Karl Johan Street* (fig.22) and the large *Spring* (fig.3) – a more academic interpretation of *The Sick Child* motif, as if to demonstrate that he too could follow the rules, if necessary. He was rewarded the Norwegian state scholarship for artists three years in a row.[11]

3. Edvard Munch
Spring 1889
Oil on canvas
169.5 × 263.5
The National Museum, Oslo

4. Edvard Munch
Night in Saint-Cloud 1890
Oil on canvas
64.5 × 54
The National Museum,
Oslo

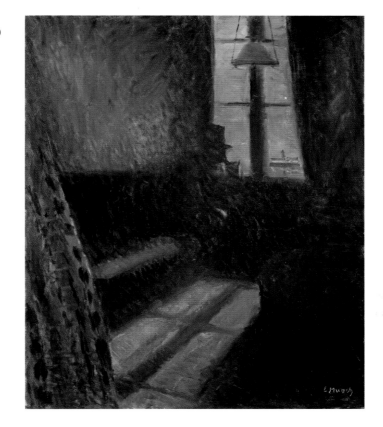

While settling in Paris in late autumn, Munch received the delayed news of his father's death. His remorseful notes at this time include statements about a new and honest art with challenging subjects. He reflected upon 'the moment when you are not yourself, only a link in the thousands of generations – procreating the human race. [...] And people should feel the sacredness of it – and take off their hats as in church.'[12]

Munch had a brief stay at Léon Bonnat's conventional studio but found more inspiration in the works of avant-garde artists such as Henri de Toulouse-Lautrec and Edgar Degas. In several works, he experimented with an impressionist approach similar to that of Claude Monet. However, Munch's crowning achievement this first winter was *Night in Saint-Cloud* (fig.4), reminiscent of a nocturne by James Abbott McNeill Whistler. In the scene, a sombre and

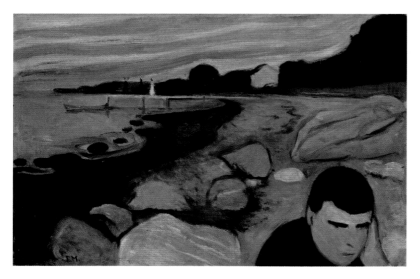

5. Edvard Munch
Melancholy 1892
Oil on canvas
64 × 96
The National Museum,
Oslo

mysterious mood pervades the dark interior where a man sits alone by a window. 'Munch's entire temperament is formed by the neurasthenic,' stated one critic. 'He belongs to the generation of fine, sickly sensitive people that we encounter more and more frequently in the newest art.'[13]

At the *Christiania Autumn Exhibition* in 1891, one controversial Munch painting was singled out for praise by Christian Krohg.[14] *Melancholy* (fig.5) presented a radically simplified seashore scene, consisting of relatively isolated, two-dimensional patches of non-realistic colour, testifying to Munch's familiarity with the synthetist approach of Paul Gauguin and his followers.[15] The setting is Åsgårdstrand, a popular fishing village south of Christiania, which Munch immortalised in his art, transforming its recognisable features into an inner, psychological landscape. 'Symbolism – Nature moulded by one's state of mind,' reads one of his aphorisms.[16]

During two winters spent in Nice, Munch produced sensuous landscapes and seascapes, and developed the key motif of *The Kiss* (fig.24). Munch also found passion and drama in gambling at the Monte Carlo Casino, another theme that he explored, further engaging with the synthetist style. The 1891 Parisian vistas, *Rue de Rivoli* and *Rue Lafayette* (fig.25) are, at first glance, run-of-the-mill impressionism, but they are imbued with a psychological tension

and a sense of alienation that is Munch's own. In early 1892, during his last stay in Nice, he expressed an ambition to paint the memory of a terrifying sunset, red as blood. [17] The resulting *Despair* is a precursor to *The Scream*.

Dividing his time between Christiania and Åsgårdstrand, he produced a noble and austere portrait of his sister Inger (fig.6), first exhibited as *Harmony in Black and Violet*; the elegiac *The Lonely Ones*, which was later lost; and the eerie *Evening on Karl Johan* (fig.27). The last of these, with its pale, distorted faces in the crowd, portrays a mood akin to that of the sensitive poetry of Sigbjørn Obstfelder and the psychological fever of Knut Hamsun's *Hunger* (1890), a classic of modern literature.

Munch's time in France had furthered a shift from a realist orientation towards symbolism, evident in his comprehensive one-man-show in 1892. Vilhelm Krag, another one of his literary friends,

6. Edvard Munch
The Artist's Sister Inger
1892
Oil on canvas
172.5 × 122.5
The National Museum, Oslo

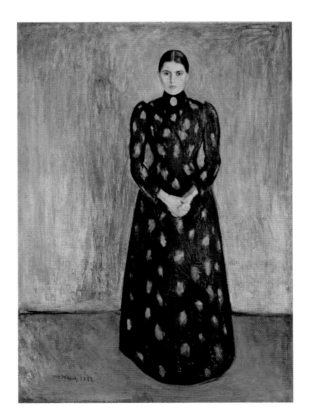

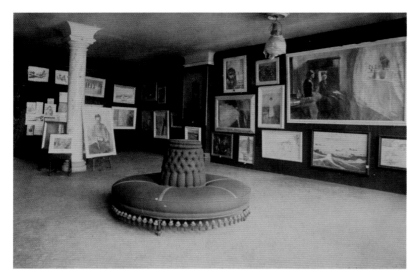

7. The Equitable Palast,
Berlin, where Munch
re-exhibited his paintings
in 1892–3, after their
removal from the Berlin
Artists' Association.

published a poem based on *Night in Saint-Cloud*. One unlikely visitor,
Eilert Adelsteen Normann, a conventional Norwegian artist residing
in Berlin, was now to play a providential role for Munch's art resulting
in an event that would have a major effect on modern art in Germany;
after conferring with his fellow members of the Berlin Artists'
Association, he invited Munch to exhibit at their premises.

Berlin – scandal and bloom

Norway was in vogue in the German capital, and Munch's art
was heralded for its Ibsen-like moods. It was immediately evident,
however, that Berlin was not ready for Munch. The public were
in uproar and the press was merciless in its critique – these were
'unfinished sketches' and 'terrible attempts', not works of art.[18]
Throughout the 1890s, Munch tended to be denounced as too
French by the Germans, and too Germanic by the French. Following
an extraordinary session and vote at the Berlin Artists' Association,
Munch's paintings were taken down just five days after the opening.[19]

Munch, however, enjoyed the benefit of all the media attention
surrounding the scandal and decided to remain in the city. He became
part of a mainly Scandinavian group of artists, initially dominated by
the Swedish dramatist, writer and painter August Strindberg (whose
portrait Munch painted that same autumn). They frequented the

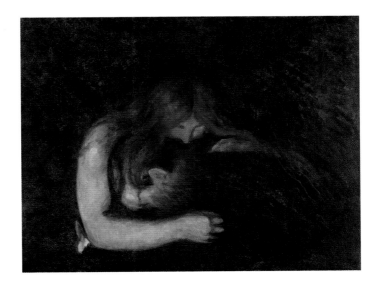

8. Edvard Munch
Vampire 1893
Oil on canvas
77 × 98
Munch Museum

tavern Zum schwarzen Ferkel (The Black Piglet), where intellectual freedom was celebrated in an atmosphere of intense socialising. In this extravagant, but highly stimulating, environment, Munch developed his own brand of expressive symbolism and created some of his most famous images. The current cliché of the *femme fatale* – woman as seductive and dangerous – was reflected in Munch's own ideas about 'the battle between the sexes called love',[20] but with their emotional intensity and ambiguity, his images manage to transcend their origins. Returning to the terrifying sunset, in 1893 he produced the iconic version of *The Scream* (fig.28), commonly regarded as a seminal work of expressionism. All traces of realism are gone; the landscape is a loose two-dimensional patchwork. Wavy lines give a sense of instability and the main figure is turned into a primitive sign, confronting the viewer as primordial terror.

Åsgårdstrand provided the setting for romantic subjects such as *The Voice*, *Starry Night* (fig.29) and *The Storm*, all with a magic glow reminiscent of Arnold Böcklin. Death motifs were steeped in emotion, not least the tragic *Death in the Sickroom* (fig.30), akin to *The Scream* in its dry flatness and pale goriness. In a large exhibition in Berlin in December, Munch brought pictures together in thematic groups under the headings of 'Love' and 'A Human Life'.

Munch's introspective images focused on the darker side of eroticism in simplified, archetypal images, an artistic counterpart to Sigmund Freud's psychological explorations in Vienna at the time. 'Munch is a Realist of the soul,' wrote Stanislaw Przybyszewski who, in 1894, initiated the first Munch monograph, which included an essay by the young Julius Meier-Graefe, later a leading art critic in Germany.[21] All the contributions focused on the 'Love' series, which included *Woman* (fig.32), *The Voice*, *Kiss* and *Love and Pain* – soon to be renamed *Vampire* (fig.8) thanks to Przybyszewski's persuasive interpretation. The work shows a man resting his head on a woman's bosom, while the woman kisses his neck. Long strands of her red hair fall over the man's head and back. The current title suggests a traditional reading of the man as prey and victim. The original title, however, opens the image to a wider range of associations.[22]

In October 1895, Munch exhibited the expanded 'Love' series in Christiania, featuring new powerful images such as *Jealousy* (fig.33) and *Ashes* (fig.34). *Ashes* was first exhibited as *After the Fall of Man*, and *Jealousy* references the same biblical story in the background scene, which alludes to a traditional emblem of Adam and Eve. The exhibition was another *succès de scandale*. Reception was negative and the public's suspicions of immorality and sensationalism were confirmed, with the iconic *Madonna* (fig.35) at the centre of controversy. Munch's exhibition was made a topic of debate at the Students' Society. Medical student Johan Scharffenberg, who later became a prominent psychiatrist, claimed that *Self-Portrait with a Cigarette* (fig.36) conveyed a man who was not normal. The writer Sigbjørn Obstfelder defended the art of his friend and kindred spirit.[23] Munch also received encouragement from Norway's international celebrity, the dramatist Henrik Ibsen: 'I will tell you something – You will experience the same as I – The more enemies you have, the more friends you will have.'[24] In the same period *Self-Portrait with a Cigarette* was purchased by the National Gallery in Norway.

In late autumn, Munch's thirty-year-old brother Andreas, newly married and working as a doctor in northern Norway, fell ill and died of pneumonia. Munch returned to spend Christmas with his family in Christiania where his sister Laura, after two years in a mental hospital, had recently moved back home with sister Inger and Aunt Karen.

Paris – second phase

In December 1895, the Parisian periodical *La Revue Blanche* published Munch's new lithographic version of *The Scream* with the artist's corresponding text, a welcome sign of interest from the true capital of modern art. Julius Meier-Graefe had moved to Paris and encouraged Munch to follow suit; so in February 1896, he left Christiania for the French capital.

Munch's experimental and provocative pictures attracted little attention at the *Salon des Indépendants*. Initiated by Meier-Graefe, eight paintings were exhibited at the new L'Art Nouveau gallery, together with his etchings and lithographs. Although critics remained aloof, here the young artist was met by more open minds. The most eccentric promotion was signed August Strindberg, now also a Paris resident. He linked a series of prose poems to Munch's paintings of love and despair, propagating Strindberg's own misogyny and Munch's art in equal measure.[25]

While in Paris, Munch received a commission to illustrate Charles Baudelaire's *Les Fleurs du Mal*, although it was later cancelled, and in 1896 and 1897 he produced lithographic flyers promoting two Ibsen plays at the Théâtre de L'Oeuvre. In his Paris studio, he painted nudes with a French flavour and, on commission, he even produced an image of an alluring mermaid. *Separation* (fig.38) and a new version of *The Voice* are both suggestive of a more accessible and decorative style.

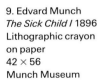

9. Edvard Munch
The Sick Child I 1896
Lithographic crayon
on paper
42 × 56
Munch Museum

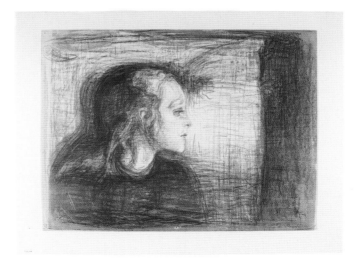

However, Munch's priority in Paris was printmaking, as he contributed to Ambroise Vollard's portfolio *Album des peintres-graveurs* (1896). Using the city's best printers, he experimented with a wide range of solutions, producing delicate colour prints using mezzotint, intaglio, lithography (fig.9) and, finally, woodcuts (fig.37). Familiar with the woodcuts of Félix Vallotton and Paul Gauguin – and certainly Japanese woodcuts – Munch turned to the medium in the autumn of 1896. Cutting along the grain and using large woodblocks, he soon started to partition the blocks with a fretsaw in order to print several colours simultaneously.[26]

Munch made lithographic portraits of Strindberg and Stéphane Mallarmé, to the poet's great satisfaction and, for the art journal *Pan*, he made an intaglio portrait of Norwegian author Knut Hamsun. Invariably electing not to exhibit at the conventional autumn exhibitions, Munch presented ten works together on a wall of their own at the *Salon des Indépendants* in spring 1897. In retrospect, he slightly over-emphasised their thematic cohesion and their positive reception, describing this collection as an important precursor to his so-called *The Frieze of Life*, as the series would be presented five years later.[27]

The current state of his art was demonstrated in a large retrospective in Christiania in autumn 1897, where a tone of respect tempered the usual hostility. For the poster, Munch chose the woodcut *Man's Head in Woman's Hair*. It seems the motif was also intended as a cover image for a future print portfolio, *The Mirror*, a graphic frieze containing several motifs of a highly literary and even metaphysical symbolism, such as *The Urn* and *Funeral March*.

The turn of a century – *fin de siècle*

In Munch's emblematic frieze motifs, an expressive potential is regularly contained in a standard compositional formula of shapes and symbolic colours constituting a private iconography. Late in 1890s, he was searching for a final statement for *The Frieze of Life*, juggling with his own compositional formulas in several large canvases, such as *Red Virginia Creeper* (fig.39), *Eye in Eye* and *Red and White*. Among his diverse output from the turn of the century, one also finds naïve and decorative landscapes, such as children walking in wonder through fairytale forests.

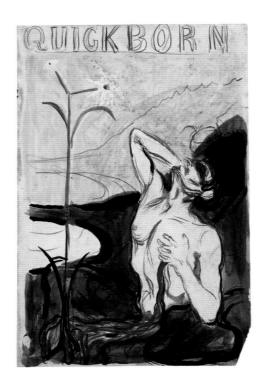

In 1898, a German journal, *Quickborn*, prepared a special issue with texts by Strindberg and images by Munch. A new motif created for the occasion, used as a cover design, was *The Blossom of Pain* (fig.10), which Munch also turned into a woodcut. The dramatic image depicts a man with a bleeding heart, bound to the earth and intensely reaching for the sky. This is *fin-de-siècle* symbolism, indebted to Michelangelo and religious imagery, while also expressing Munch's epigrammatic philosophy: 'Art is the Blood of Your Heart.'[28]

In August, Munch purchased a little house in Åsgårdstrand and met the attractive and moneyed Tulla Larsen. He painted her portrait, and she most likely posed for the monumental *Metabolism* (fig.40). The painting (first entitled *Adam and Eve)* was fitted with a large wooden frame, decorated with carved motifs that integrated it with the main subject; a city prospect in the upper part and tree roots and two skulls in the lower part. Painted in a semi-academic style akin to Hans von Marées or Franz von Stuck, Munch later stated that it was

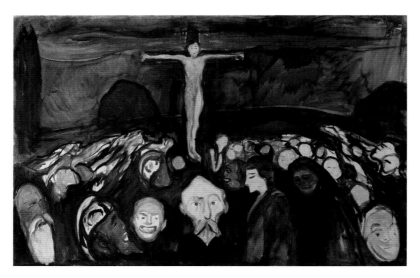

11. Edvard Munch
Golgotha 1900
Oil on canvas
80 × 120
Munch Museum

'as important to the Frieze as the buckle to a belt'.[29]

Munch's travels with Tulla Larsen to Berlin, Paris and Florence in spring 1899 marked the beginning of a fateful affair. While spending the summer in Åsgårdstrand, Munch made several paintings in a colourful synthetist style; the monumental *The Dance of Life* (fig.41) is a vital and decorative revision of *Woman* (fig.32), again dealing with love, state of mind and phases of existence. Large bordered areas of strong, uniform colour make for a strikingly unique contender as a concluding statement for *The Frieze of Life*.

Revealing the complexities of love, Munch suggested a *pro forma* marriage to Tulla Larsen, before withdrawing to a sanatorium near Lillehammer.[30] *Golgotha* (fig.11), inscribed 'Kornhaug Sanatorium 1900', is a violent expression of the zeitgeist of confusion and apocalypse. On some level the suffering outcast, the wretched figure on the cross, also relates to the artist, and the faces in the crowd appear familiar. A harrowing summer with Tulla Larsen culminated in a break-up and Munch's work was suffering. Depressed, he sought refuge at Birgitte Hammer's Pension, a boarding-house overlooking the fjord just south of Christiania.

In autumn 1900, Meier-Graefe published a harsh critique of Munch's art, complaining that his paintings were 'pure denials' and 'mere thoughts'.[31] In *Fertility* (fig.42), an uplifting and accessible

image referencing the popular French realist Jean-François Millet,
Munch appears to respond to this critique.[32] That winter Munch
produced a series of decorative and evocative landscapes, including
White Night (fig.43) and *Train Smoke*. Bereft of literary content, they
were akin to the expressive work of Vincent van Gogh, Meier-Graefe's
recommended model. The following summer in Åsgårdstrand, Munch
painted *The Girls on the Bridge* (fig.44), probably his most cherished
work – then and now. The scene is a harmonious and subtle paean to
Nordic summer nights, painted in saturated, yet translucent colours.[33]

1902 – victory and tragedy

Ten years after the scandalous Berlin show in 1892, Munch was
invited to participate at the Berlin Secession. This was the first full
presentation of *The Frieze of Life*. Twenty-two paintings were divided

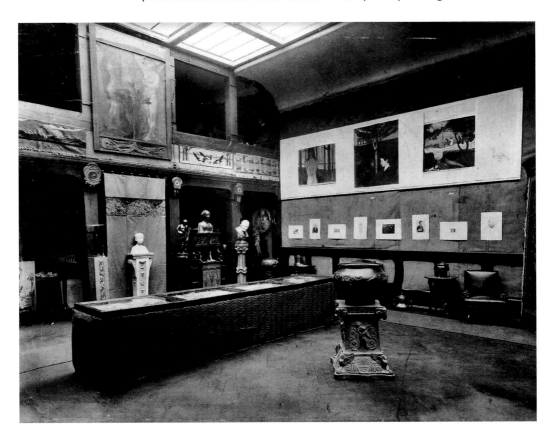

into four sections: 'Seeds of Love', 'Love's Blossom and Decay', 'Life's Anxiety' and 'Death'. Emphasising the concept of a frieze, the paintings were hung high on the walls on a white panel that ran around the entire room. In the earlier 'Love' series, *The Scream* had been the concluding statement; the new frieze included death, with *Metabolism/Life and Death* underlining the cyclical aspect of life (fig.12).

Munch's promise to marry Tulla Larsen had been left hanging in the air and, after a half-hearted suicide attempt on her part, the matter was finally resolved in September with a shooting incident in Munch's house in Åsgårdstrand. Drunk and despairing, Munch accidentally shot himself in his left hand, rendering his middle finger permanently crippled. Although he was outwardly free from Tulla Larsen, in a psychological sense the bleeding from the gunshot never ceased and the affair continued to haunt his life and work.

Late in 1902, with his left hand bandaged, Munch left for Lübeck and Dr Max Linde. Linde was the owner of a large collection of Auguste Rodin's works, Munch's *Fertility* and a large number of his prints. He was at the time putting the finishing touches to a small book, *Edvard Munch and the Art of the Future*.[34] While a guest, Munch produced the *Linde Portfolio*; prints of the family, the house and the park. The following spring, he returned to paint *Dr Linde's Sons* (fig.45), a significant work in twentieth-century portraiture.

Supporters began to emerge who had a strong faith in the fragile and reckless Norwegian. Aficionado Albert Kollmann was an efficient marketer and interest in Munch's graphic work was growing. County judge Gustav Schiefler discovered Munch's prints, and was soon busy preparing the first catalogue of his graphic works.[35]

Success and creeping shadows
At the *Salon des Indépendants* in Paris in 1903, Munch received more attention than at previous shows; his raw and colourful images were following a path similar to that of the emerging French fauves. That spring Munch fell deeply for a beautiful violinist, Eva Mudocci, who was also acquainted with Henri Matisse.[36] Munch made exquisite lithographic portraits of Eva and her pianist companion, Bella Edwards (fig.46). However, Tulla Larsen continued to haunt Munch's mind and 'The Tulla affair' was taking on a life of its own, growing out of

all proportion. Former friends were condemned as foes; in Munch's graphic imagination his two arch-enemies were transformed into a poodle and a toad-pig.[37]

Following a successful exhibition at the Vienna Secession in 1904, Munch went to Weimar, where he painted the portrait of the influential Count Harry Kessler and enjoyed the elevated social life centring around the Grand Duke. His nervous condition was unstable, however, and his frequent drinking turned from a bad habit into alcohol abuse, causing embarrassment in this new upper-class circle of friends.

To Munch's delight, Dr Linde commissioned a frieze for his children's room, for which he easily found suitable subjects and settings in Åsgårdstrand (fig.47) and Christiania. During this period, with the help of friends, *The Frieze of Life* – or *Scenes from the Modern Life of the Soul,* as it was now called – was presented in Christiania to a near positive reception. Munch's old friend, art historian Jens Thiis, lectured on his art. Returning to Lübeck, Munch painted *Self-Portrait with Brushes*, a visual counterpart to his portrait of Dr Linde. However, Munch received a hard blow – personally and financially – when Linde rejected the commissioned frieze.[38]

In Norway, the summer of 1905 was filled with political drama. On 7 June, the Norwegian Parliament nullified the country's personal union with Sweden and months of tension and negotiations ensued until the new state of affairs was accepted. Munch's summer in Åsgårdstrand was full of nervousness, heated debate and heavy drinking. A literal falling out with his admirer Ludvig Karsten – they tumbled down the stairs from Munch's veranda, fighting – was followed by a hasty departure from the country. For four years, Munch did not return to his homeland.

Portraits, plays and problems
The favourable reception in Berlin in 1902 had resulted in a number of portrait commissions by prominent German collectors and their families. In the new century, Munch's portraits were crucial to his growing fame, but his symbolist images were still hard to digest for many. In 1906, he made a monumental portrait of the philosopher Friedrich Nietzsche (fig.48) – who had died in 1900 – commissioned by the Swedish banker Ernest Thiel, a generous supporter of the

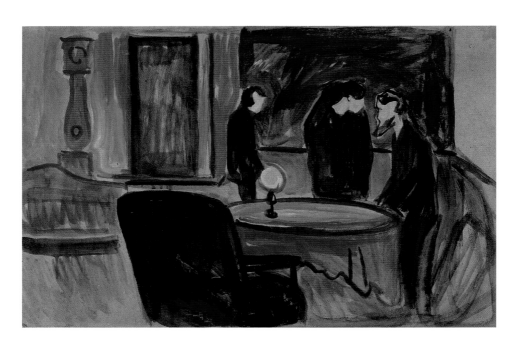

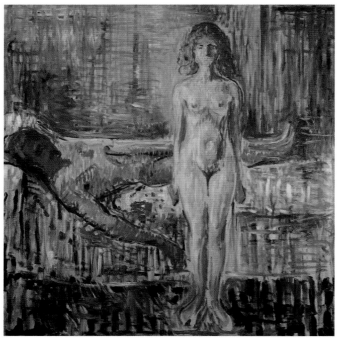

13. Edvard Munch
Set design for Henrik Ibsen's 'Ghosts' 1906
Tempera on unprimed canvas
45.7 × 76.5
Munch Museum

14. Edvard Munch
The Death of Marat II 1907
Oil on canvas
153 × 149
Munch Museum

Nietzsche Archive in Weimar, a shrine for the philosopher presided over by his sister Elisabeth Förster-Nietzsche. Munch also painted portraits of Thiel and Förster-Nietzsche. Trying to come to grips with his alcoholism and nervous condition, he spent time at various spas in the district of Thuringia.

Henrik Ibsen died in May 1906, and Munch was asked by theatre director Max Reinhardt to provide mood sketches for a staging of *Ghosts* (1881) at his chamber theatre at the Deutsches Theater in Berlin (fig.13). The play's main character, *Osvald* – a talented painter from a distinguished family, inclined to drinking, ailing and doomed – was one whom Munch clearly identified with, as seen in his *Self-Portrait with a Bottle of Wine* (fig.49) painted in the same period. He also created a decorative frieze for Max Reinhardt's theatre and was involved with a staging of *Hedda Gabler* in 1907.

Warnemünde
After visiting Linde in spring 1907 – painting *The Harbour in Lübeck* (fig.50) – Munch spent the summers of 1907 and 1908 in the fishing town and popular seaside resort of Warnemünde on the German Baltic coast. Here he developed a new style in a number of paintings: vital and stern, like a sparse loom of long brushstrokes, it was distinct from the soft lines and opaque colours of his more well-known works. *The Death of Marat* (fig.14), Munch's take on the French Revolution martyr and Jacques-Louis David's icon, can be read as a statement on the battle between the sexes, with the losing party left bleeding on the battleground. A private reference to the shooting incident is obvious. With the fashion for *vitalism* and the German *Lebensreform* movement as a backdrop, Munch's momentous project in Warnemünde was *Bathing Men* (fig.52), a provocative vision of vital, masculine strength, painted in a constructive, Cézanne-like fashion. The German Brücke artists were now following Munch with special interest, but invitations to exhibit with the group came to nothing. The battle with 'the enemy' (Tulla Larsen and her friends) continued – in letters, lithographs and fiction.

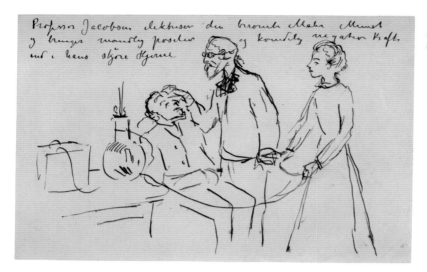

15. Edvard Munch
Dr Jacobson electrifies the famous painter Munch ...
1908
Ink on paper
13.7 × 21.2
Munch Museum

Fall and triumph

Alarming symptoms of exhaustion persisted and Munch, feeling persecuted by the police in Warnemünde, escaped to Denmark. After heavy bouts of drinking, he collapsed and eventually submitted himself to treatment at Dr Jacobson's clinic in Copenhagen. From Norway he received the Royal Order of St Olav – 'a hand stretched out from my country'.[39] A ban on alcohol, combined with calm, care and cooking gradually brought him back to his feet, his creativity intact (fig.15). The Tulla Larsen fixation survived, however. Animal studies done at a nearby zoo were exploited for a series of lithographs illustrating a sarcastic prose poem about *Alpha and Omega*, the first two human beings. Munch's renewed vitality is evident in the portrait *Daniel Jacobson* (fig.53), a mischievous masterpiece, and in *Self-Portrait in the Clinic* (fig.54), which portrays the artist as energetic and impatient, sitting in a chair by an open window; large, fragmented brushstrokes drifting into place. A successful exhibition was arranged in the Danish capital and Munch's final breakthrough in his home country was heralded with a show at his favourite gallery, Blomqvist, staged by faithful friends. Jens Thiis, recently appointed director of the National Gallery in Christiania, also made an extensive purchase of Munch's artworks.

Repatriated – laurels and little rest

After almost seven months, Munch left the clinic in Copenhagen in 1909. Sailing to Norway, he scanned the coastline and settled in Kragerø, a small town 140 km south-west of Christiania, renting the estate Skrubben. Adding to an important genre, he painted what he called 'my art's bodyguards', full-figure portraits of his friends.[40] With an emphasis on external reality, the rugged coast and pine forests were translated into paintings endowed with a new down-to-earth rawness and sensuous gusto. The dynamic perspective in *The Yellow Log* (fig.55) draws the viewer into a sparse and wintry forest of bluish, columnar pines.[41]

Preparing for its centennial, The Royal Frederik University in Christiania issued a competition for the decoration of its new festival hall, the Aula, a commission of the highest national prestige. Munch worked tirelessly on the project for years, gradually gaining support for his unorthodox approach. In large outdoor studios, he developed the epic subjects *History* (fig.56) and *The Sun*, extracting emblematic and symbolic images from his Kragerø surroundings. In 1910, he bought a small estate in Hvitsten, on the east side of the Oslofjord. Its fertile and calm scenery is recognisable in *Alma Mater*, the counterpart to *History*. The monumental decorations for the Aula were inaugurated in 1916, seven years after Munch had begun work on them, yet managed to convey a daring spontaneity of execution, frequently

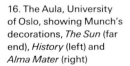

16. The Aula, University of Oslo, showing Munch's decorations, *The Sun* (far end), *History* (left) and *Alma Mater* (right)

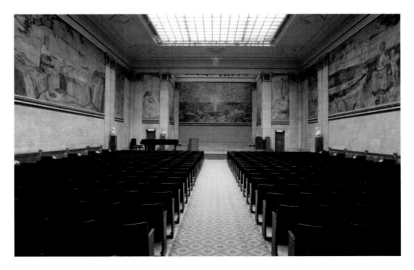

reminiscent of improvised watercolours and unlike any contemporary decorations. With his chosen content, Munch had fulfilled their ceremonial function, cunningly combining the national and the universal, the academic and the popular (fig.16).[42]

Since Munch's time in Warnemünde, workers had become a prominent subject, an interest that continued in Kragerø, where *Workers in the Snow* was painted. The large *Workers on their Way Home* (fig.57) was executed in Moss and exploits perspective, space and movement in an expressionistic, cinemascopic way.

The 1912 Sonderbund exhibition in Cologne is a milestone in the history of art and is considered the first comprehensive presentation of modern art – termed 'expressionism' – honouring its founders and exponents. Munch had a room of his own; twenty years after the scandal in Berlin, he was raised to the level of Van Gogh, Gauguin and Cézanne as one of four pioneers of modern art, and the only one still alive and active.

17. Edvard Munch
Spring Ploughing 1916
Oil on canvas
84 × 109
Munch Museum

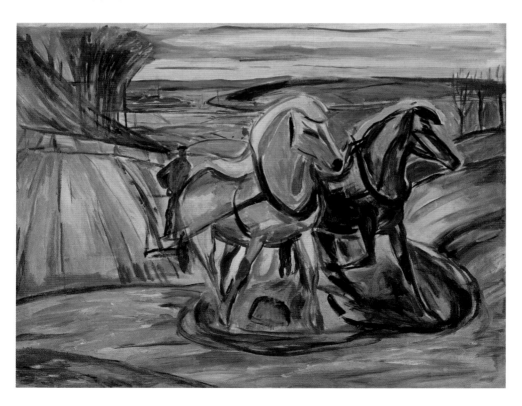

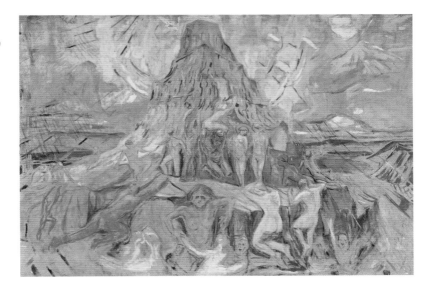

18. Edvard Munch
*The Human Mountain
(Towards the Light)* 1927–9
Oil on canvas
300 × 420
Munch Museum

Ekely – the late Munch

In 1916, Munch settled for good at Ekely, an estate on the rural outskirts of the capital.[43] A vast body of lesser-known works date from this late period; paintings, prints and monumental projects. Remaining an active and astute marketer, he arranged exhibitions at home and abroad. He adopted new subjects and developed a looser, brighter painting style. A number of young female models posed for the famous artist (fig.58), sometimes staying at Ekely and working as housekeepers. Otherwise, Munch lived a life of increasing seclusion.

Munch's late paintings transcend the popular conception of the artist, or the 'mythic Munch'.[44] At Ekely – and similar locations – he portrayed the rural surroundings in a large number of canvases, often including man in active contact with nature, as in *Spring Ploughing* (fig.17), *The Haymaker* and *Man in the Cabbage Field* (fig.59) – contemporary with and in a similar vein to Knut Hamsun's 1917 novel *Growth of the Soil*.

An exhibition at Blomqvist in 1918 carried the title *The Frieze of Life*. In the catalogue, Munch explained the origin of the Frieze and his own intentions, rebuffed the harsh reviews in the press and argued for a public commission for him to repaint and integrate its main elements in a suitable setting. Many core works from the 1890s had been

sold, and *The Frieze of Life* was to remain an elusive and ambiguous concept, an idea never fully realised. A more light-hearted version did materialise, however, with the *Freia Frieze* (1920–22) painted for the staff canteen of a chocolate factory in Christiania. In the wake of the Aula project, Munch developed sketches for a 'Worker Frieze', and for many years he was preoccupied with *The Human Mountain* (fig.18), a symbolic and philosophical subject on a monumental scale, originating in his sombre lithograph *Funeral March* from 1897.[45]

In the last decades of the artist's life, the self-portrait was a particularly significant genre.[46] Munch traced the visible passage of time and mapped the ever-changing landscape of the human soul, acting out a variety of roles: *The Night Wanderer* 1923–4 is suggestive of dark drama; the sunny *Self-Portrait in Front of the House Wall* (fig.61) is full of vibrant energy; and the symbolic and ceremonial *Between the Clock and the Bed* (fig.62) appears to signal his final departure.

Large exhibitions in the National Galleries of Germany and Norway in 1927 confirmed Munch's unique significance in the course of modern art. Eleven years later, some eighty of his paintings were removed from German museums by the Nazi regime. In 1940, Norway was occupied and Munch's great concern was for the safety of his works. A few days before his eightieth birthday, a German ammunition ship exploded in Oslo harbour, causing windows to break as far away as Ekely. This may have been the cause of Munch's pneumonia. In the company of his housekeeper, he died quietly on 23 January 1944.

Edvard Munch never ceased to explore the fundamentals of the painterly approach. However, at the heart of it all was an inner drive to communicate his experience of life. Man is the measure of all things, as Oskar Kokoschka noted. An element of the critic Clement Greenberg's puzzled fascination with the expressionist may well lie in Munch's existential commitment to his art. This is manifest in its human directness, depth and diversity, lending it an enduring appeal to a broad public and discerning critics alike.

19. Ragnvald Vaering
Munch at Ekely,
December 1943
Munch Museum

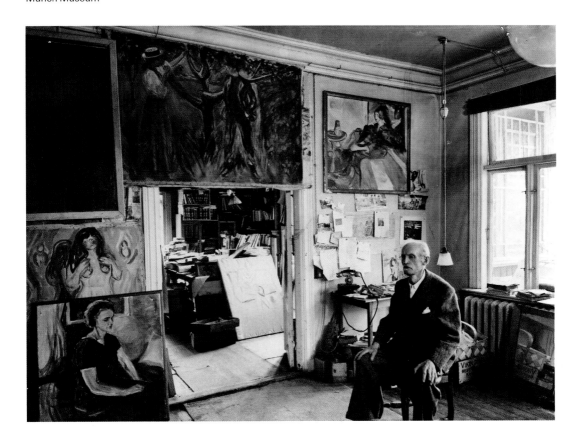

20
Morning 1884
Oil on canvas
96.5 × 103.5
Bergen Art Museum

21
The Sick Child 1885–6
Oil on canvas
120 × 118.5
The National Museum,
Oslo

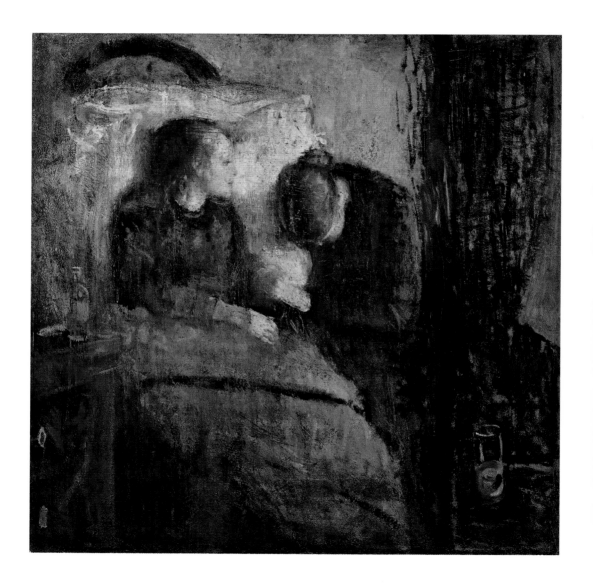

22
Music on Karl Johan Street
1889
Oil on canvas
102 × 141.5
Kunsthaus Zurich

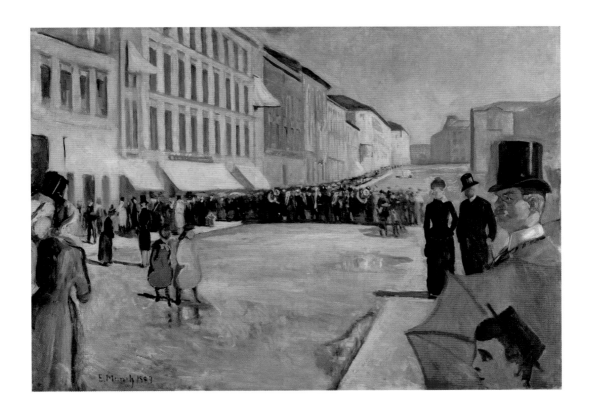

23
Summer Night (Inger on the Beach) 1889
Oil on canvas
126.5 × 161.5
Bergen Art Museum

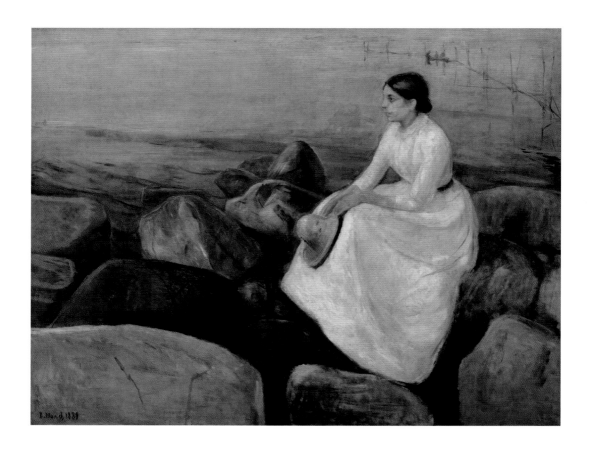

24
Kiss by the Window 1892
Oil on canvas
73 × 92
The National Museum,
Oslo

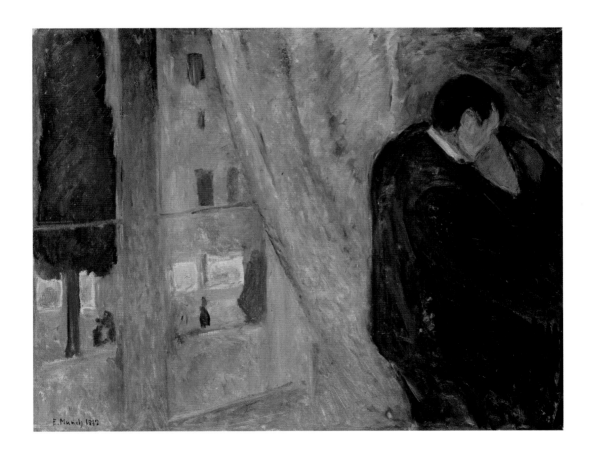

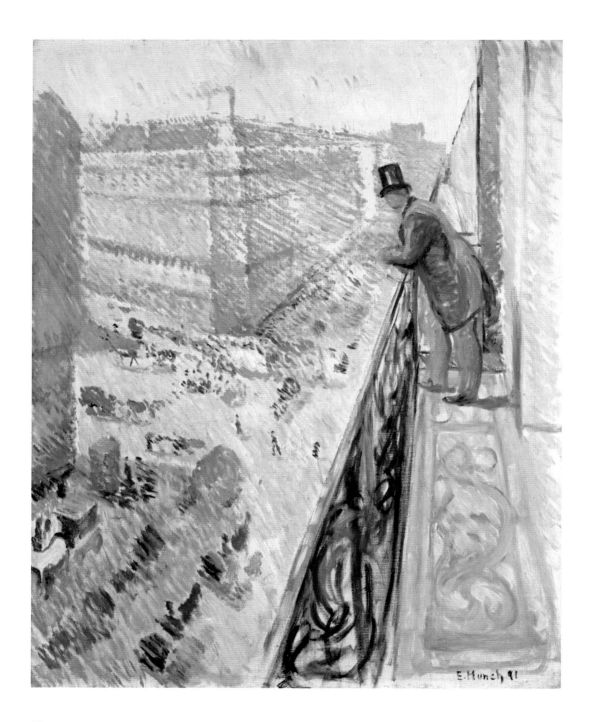

E.Munch 91

36

25
Rue Lafayette 1891
Oil on canvas
92 × 73
The National Museum,
Oslo

26
From the Riviera 1892
Oil on canvas
46.5 × 69
Munch Museum

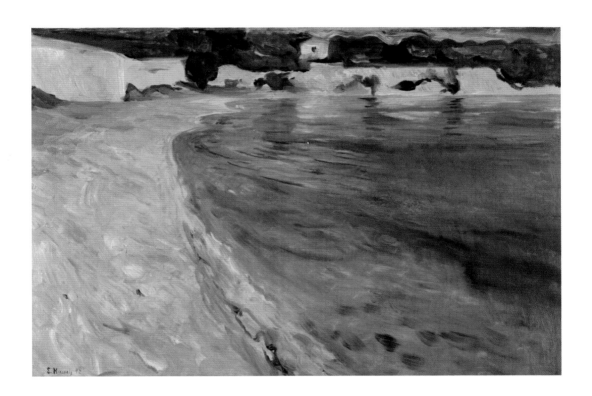

27
Evening on Karl Johan
1892
Oil on canvas
84.5 × 121
Bergen Art Museum

28
The Scream 1893
Tempera and crayon on
unprimed cardboard
91 × 73.5
The National Museum,
Oslo

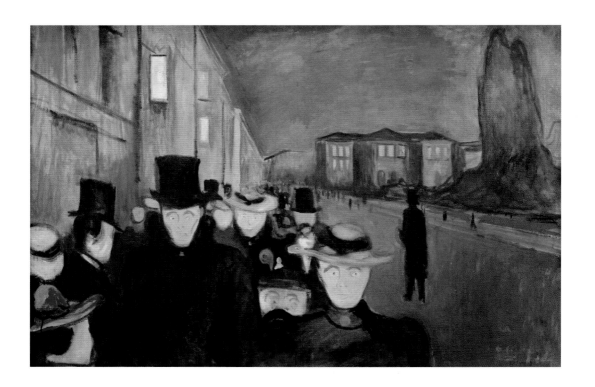

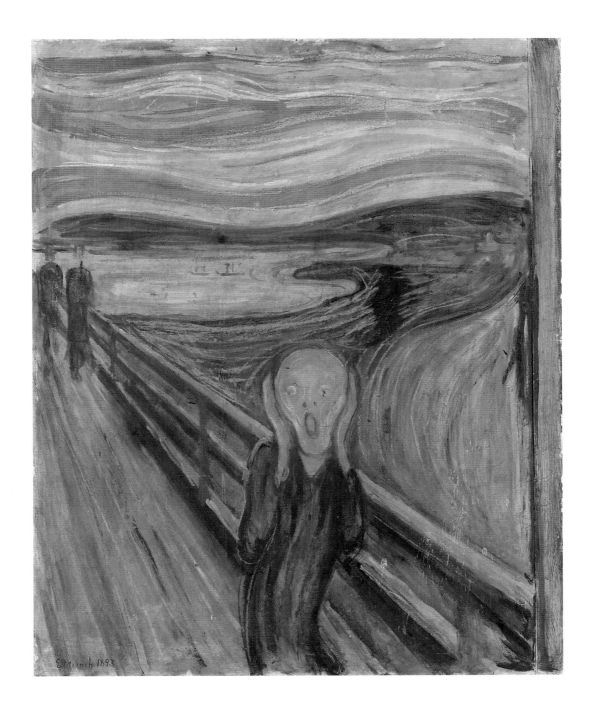

29
Starry Night 1893
Oil on canvas
135.5 × 140
The J. Paul Getty Museum,
Los Angeles

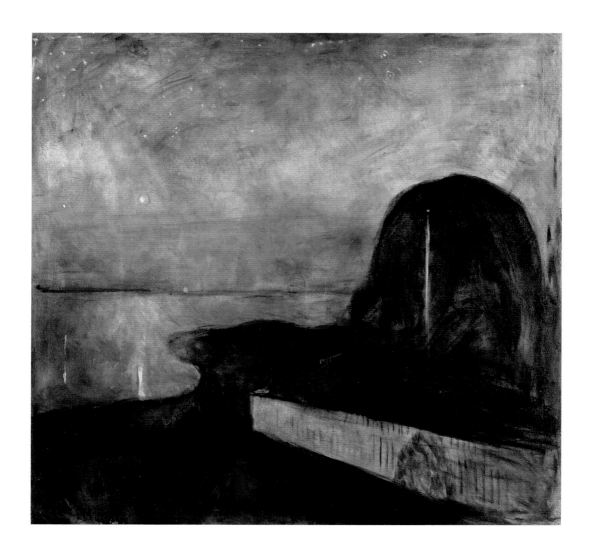

30
Death in the Sickroom 1893
Tempera and crayon on
canvas
152.5 × 169.5
The National Museum, Oslo

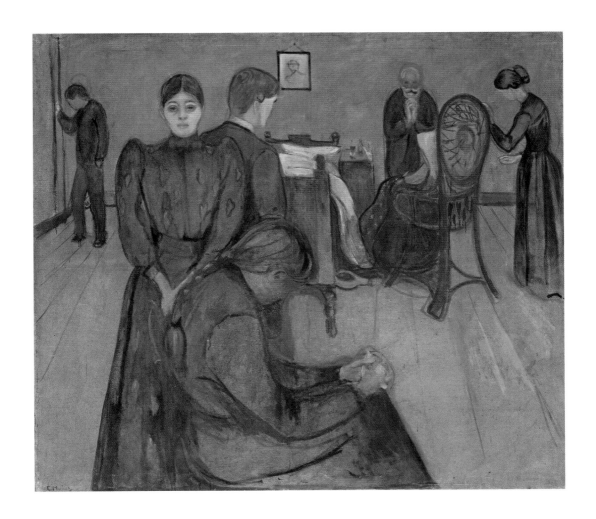

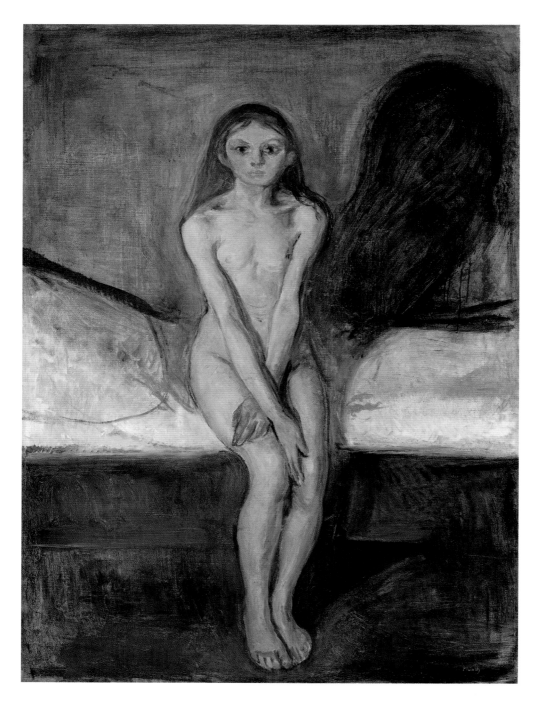

31
Puberty 1894–5
Oil on canvas
151.5 × 110
The National Museum,
Oslo

32
Woman 1894
Oil on unprimed canvas
164.5 × 251
Bergen Art Museum

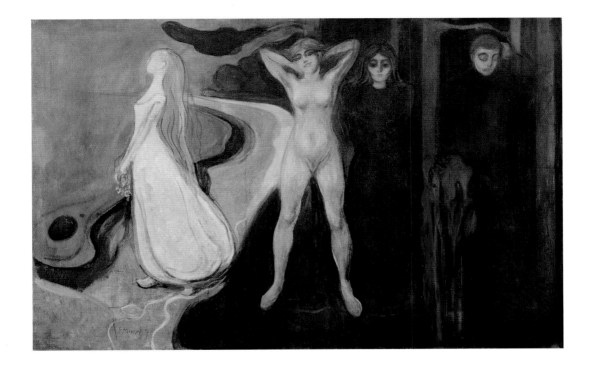

33
Jealousy 1895
Oil on canvas
66.8 × 100
Bergen Art Museum

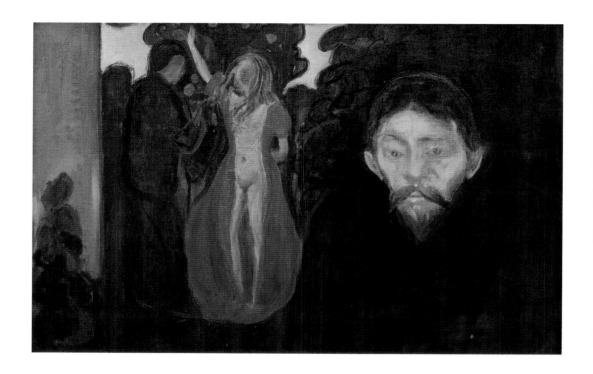

34
Ashes 1895
Oil on canvas
120.5 × 141
The National Museum,
Oslo

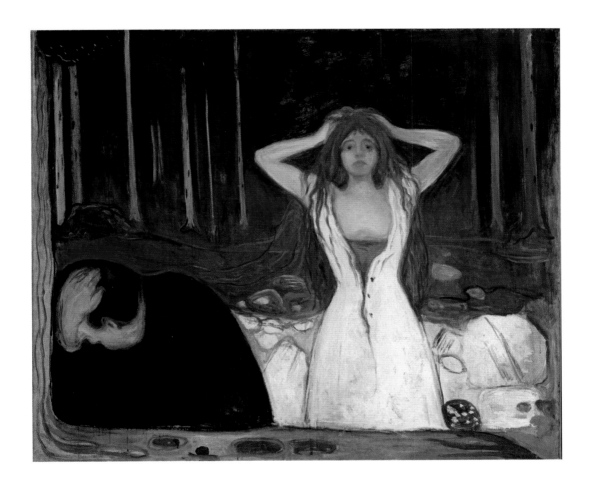

35
Madonna 1894
Oil on canvas
90 × 68.5
Munch Museum

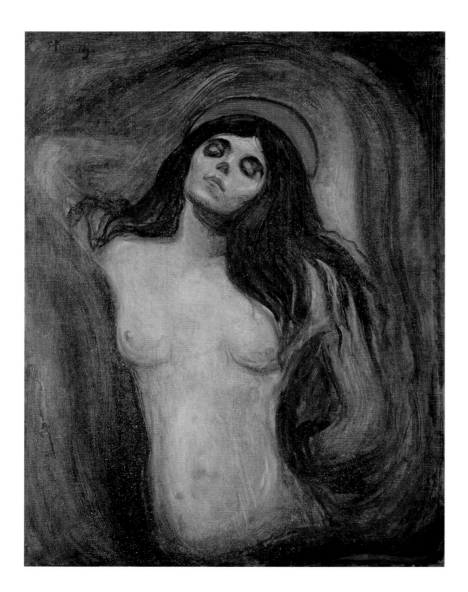

36
*Self-Portrait with a
Cigarette* 1895
Oil on canvas
110.5 × 85.5
The National Museum,
Oslo

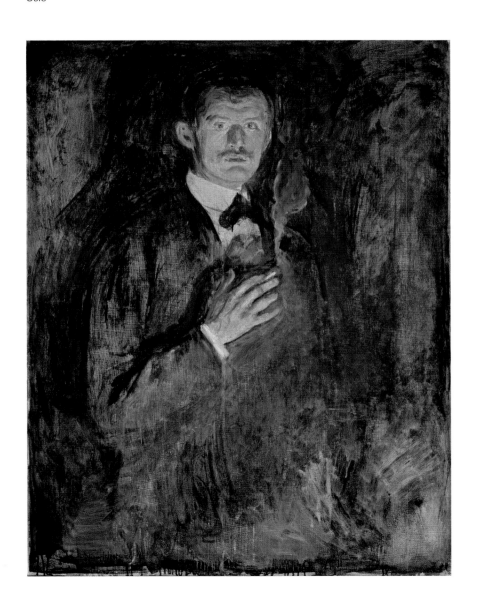

37
The Kiss IV 1902
Woodcut with gouges
and fretsaw
47 × 47
Munch Museum

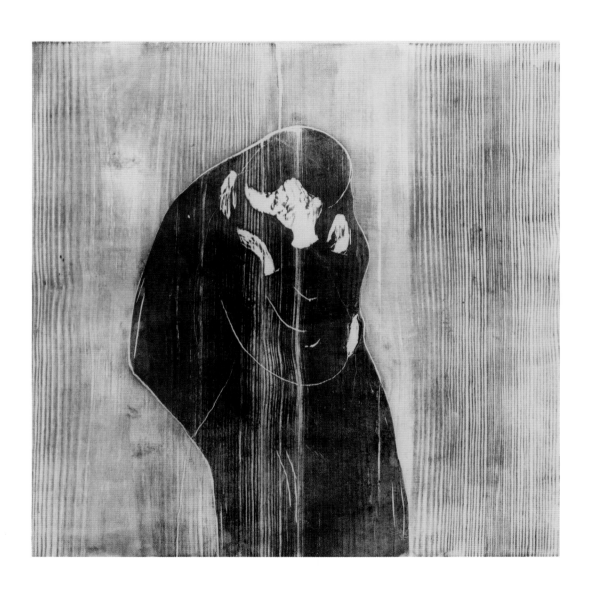

38
Separation 1896
Oil on canvas
96.5 × 127
Munch Museum

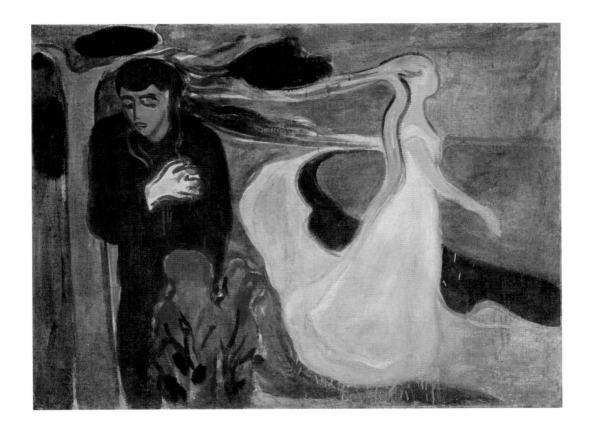

39
Red Virginia Creeper
1898–1900
Oil on canvas
119.5 × 121
Munch Museum

40
Metabolism 1898–9
Oil on canvas
172.5 × 142
Munch Museum

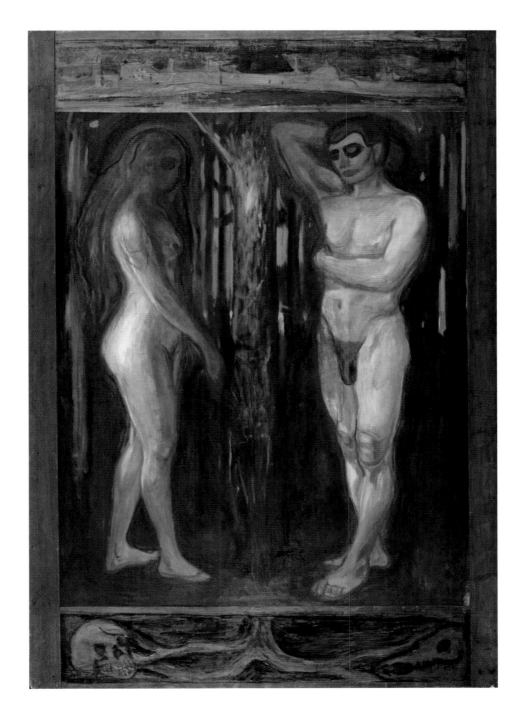

41
The Dance of Life
1899–1900
Oil on canvas
125 × 191
The National Museum,
Oslo

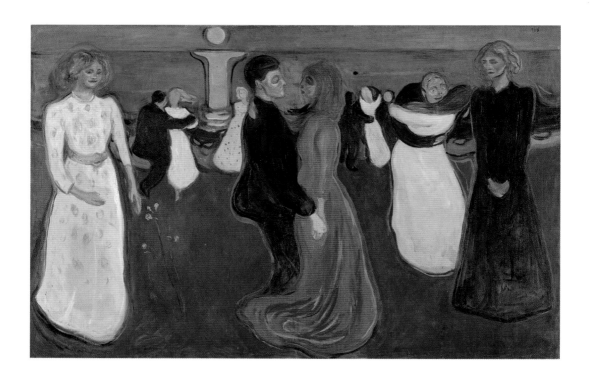

42
Fertility 1899–1900
Oil on canvas
120 × 140
Private collection

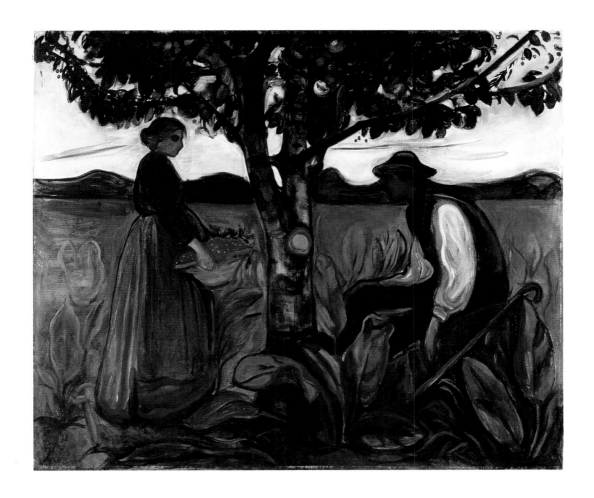

43
White Night 1900–1
Oil on canvas
115.5 × 111
The National Museum,
Oslo

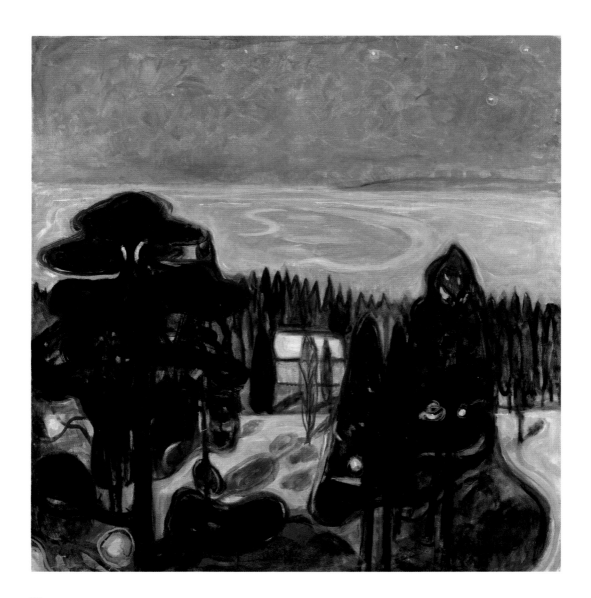

44
The Girls on the Bridge
1901
Oil on canvas
136 × 125
The National Museum,
Oslo

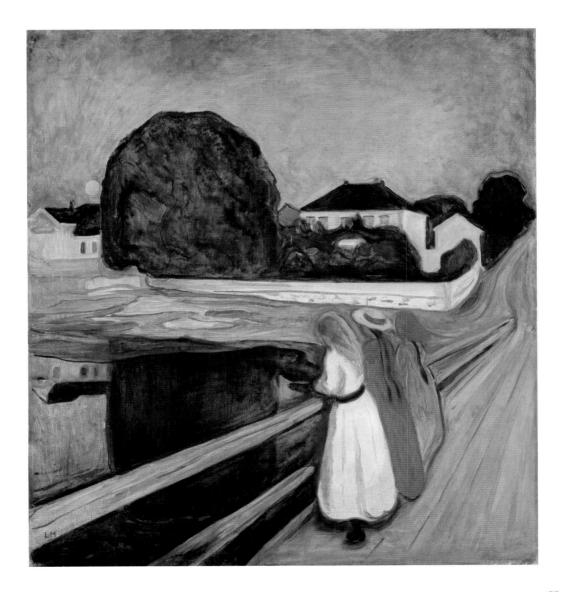

45
Dr Linde's Sons 1903
Oil on canvas
144 × 199.5
Museum für Kunst und
Kulturgeschichte der
Hansestadt, Lübeck

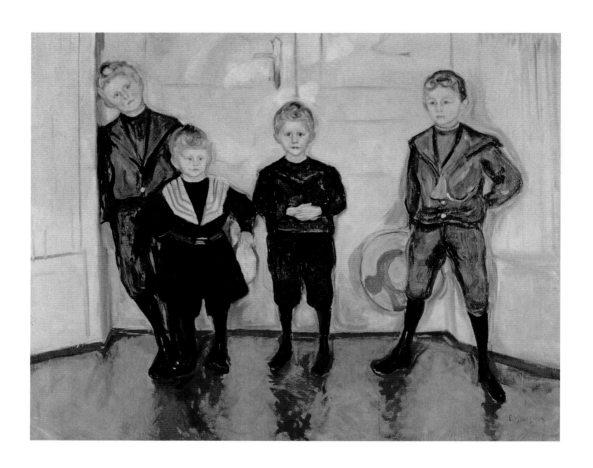

46
Violin Concert 1903
Lithograph, crayon and
touche
48 × 56
Munch Museum

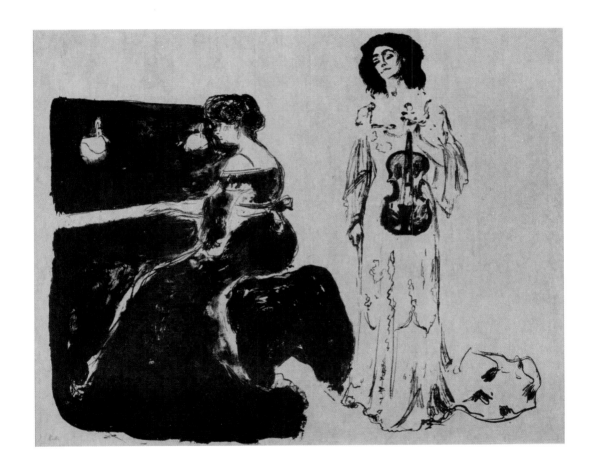

47
*Trees by the Beach
(Linde Frieze)* 1904
Oil on canvas
93 × 167
Munch Museum

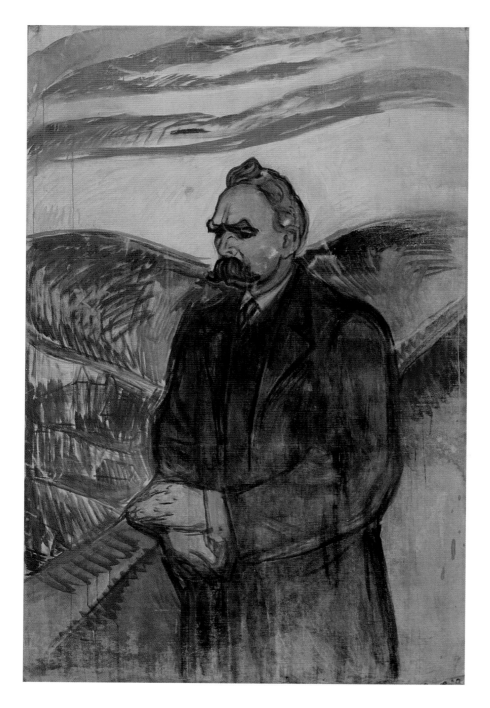

48
Friedrich Nietzsche 1906
Oil and tempera on canvas
201 × 130
Munch Museum

49
*Self-Portrait with a Bottle
of Wine* 1906
Oil on canvas
110.5 × 120.5
Munch Museum

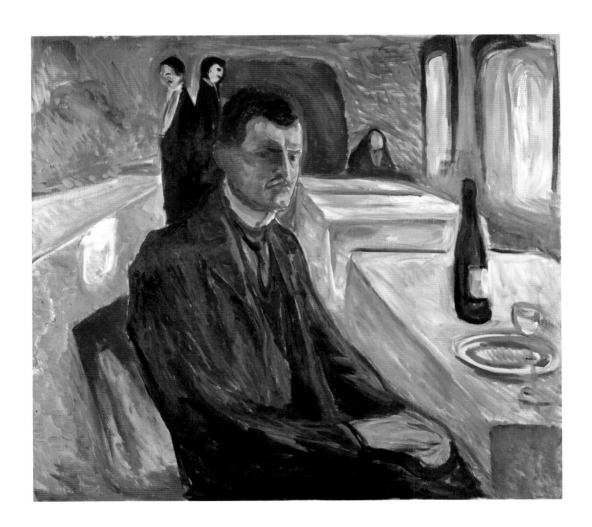

50
The Harbour in Lübeck
1907
Oil on canvas
81.5 × 122
Kunsthaus Zurich

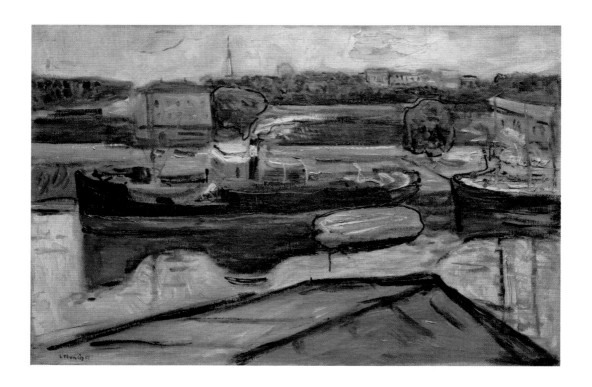

51
Weeping Woman 1907
Oil on canvas
121 × 119
Munch Museum

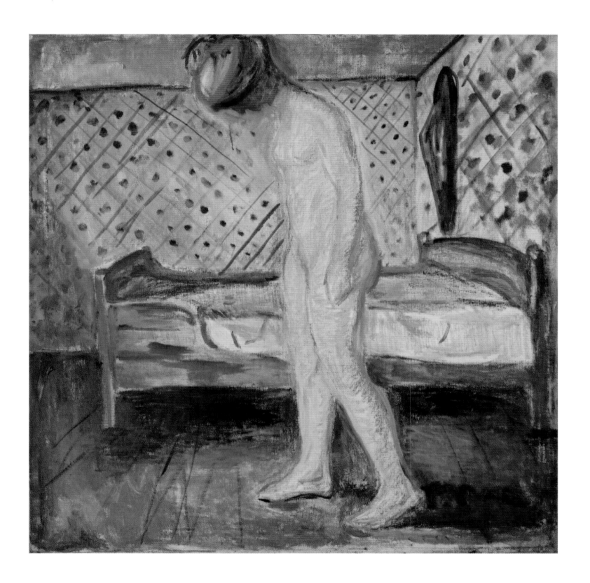

52
Bathing Men 1907–8
Oil on canvas
206 × 227
Antell Collections,
Ateneumin Taidemuseo,
Helsinki

53
Daniel Jacobson 1908–9
Oil on canvas
204 × 111.5
Munch Museum

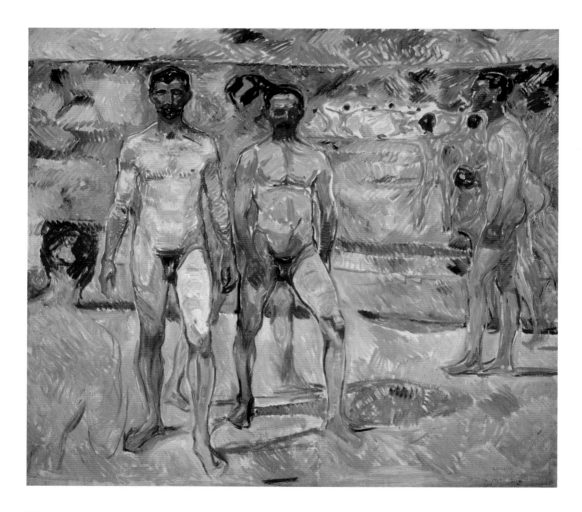

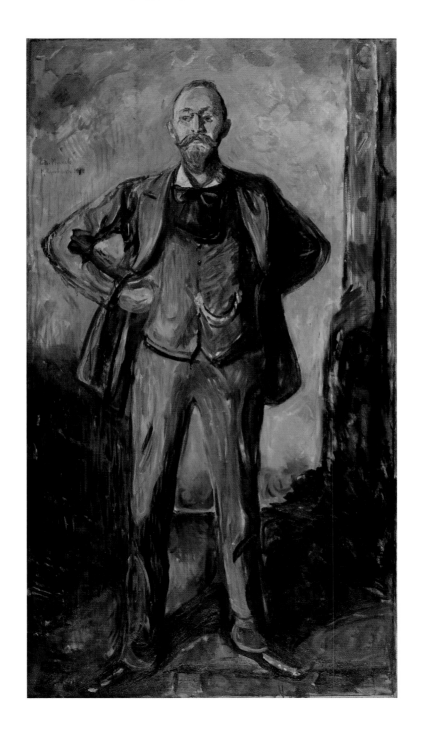

54
Self-Portrait in the Clinic
1909
Oil on canvas
100 × 110
Bergen Art Museum

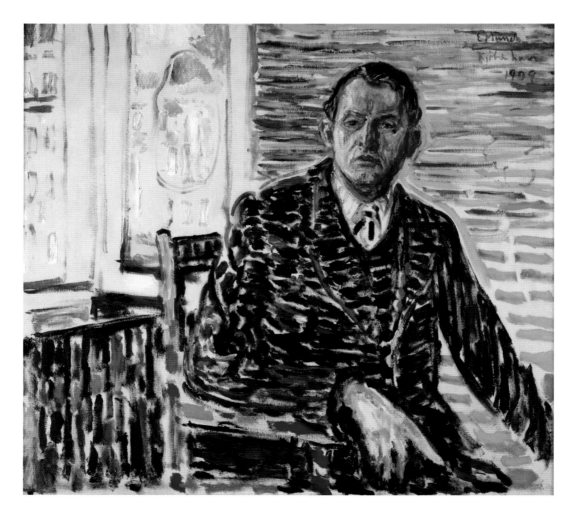

55
The Yellow Log 1912
Oil on canvas
129 × 160.5
Munch Museum

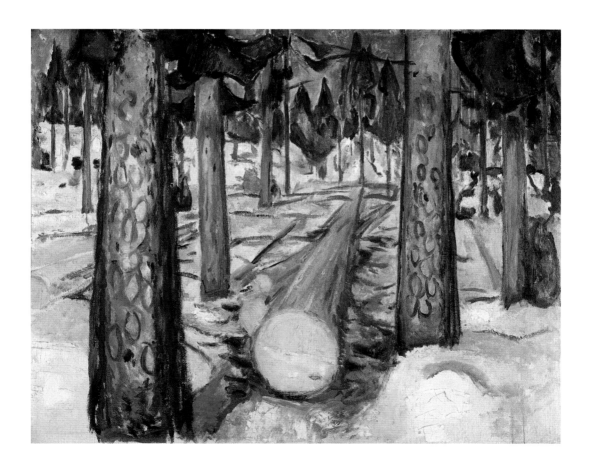

56
History 1911/1914–16
Oil on canvas
455 × 1160
The Aula,
University of Oslo

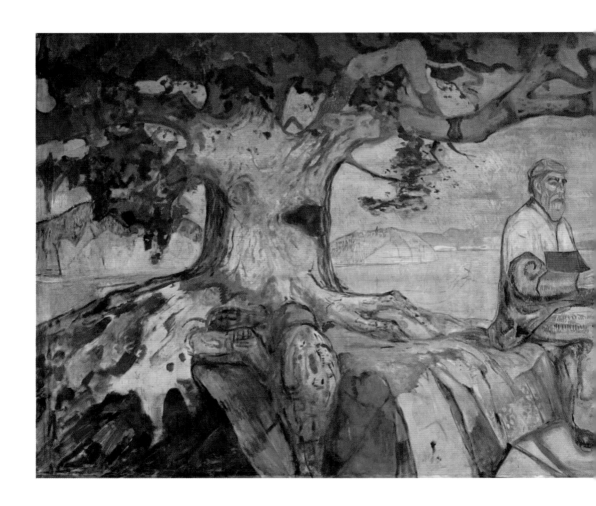

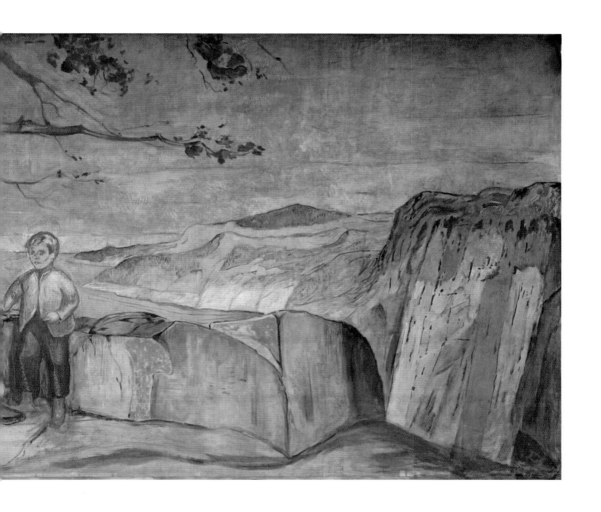

57
*Workers on their Way
Home* 1913–14
Oil on canvas
201 × 227
Munch Museum

58
*Seated Model on the
Couch* 1924–6
Oil on canvas
136.5 × 115.5
Munch Museum

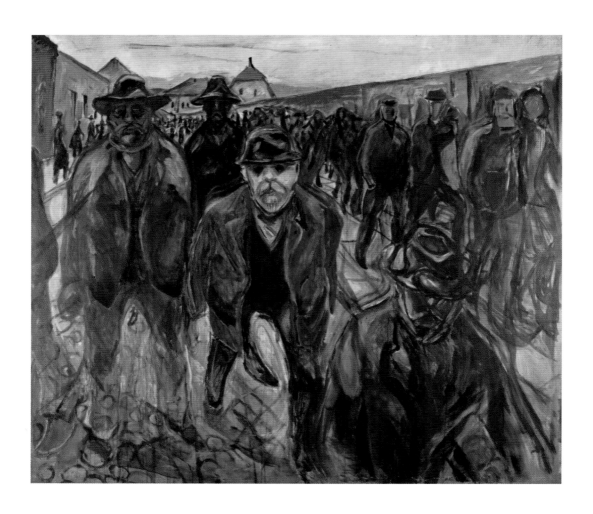

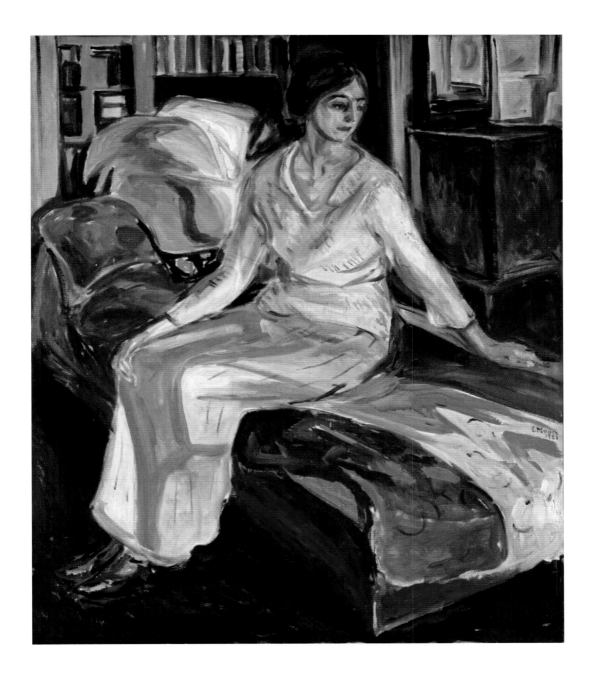

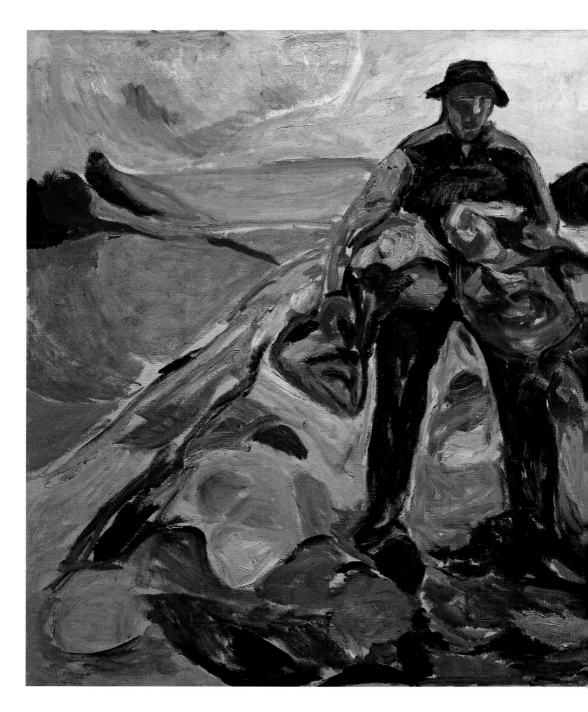

59
Man in the Cabbage Field
1916
Oil on canvas
135 × 180
The National Museum,
Oslo

60
Starry Night 1922–4
Oil on canvas
140 × 119
Munch Museum

61
*Self-Portrait in Front of the
House Wall* 1926
Oil on canvas
91.5 × 73
Munch Museum

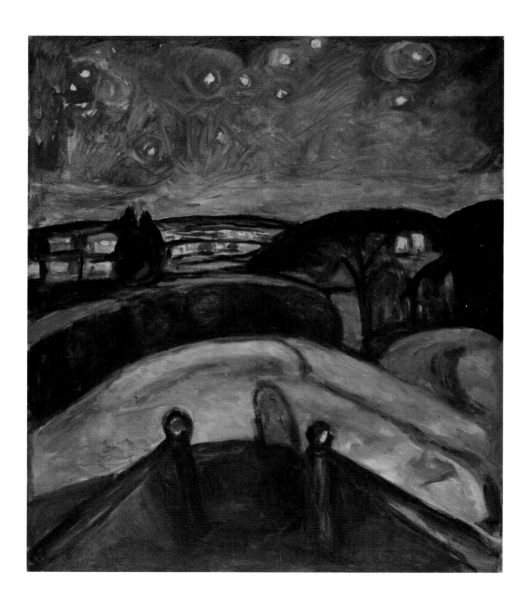

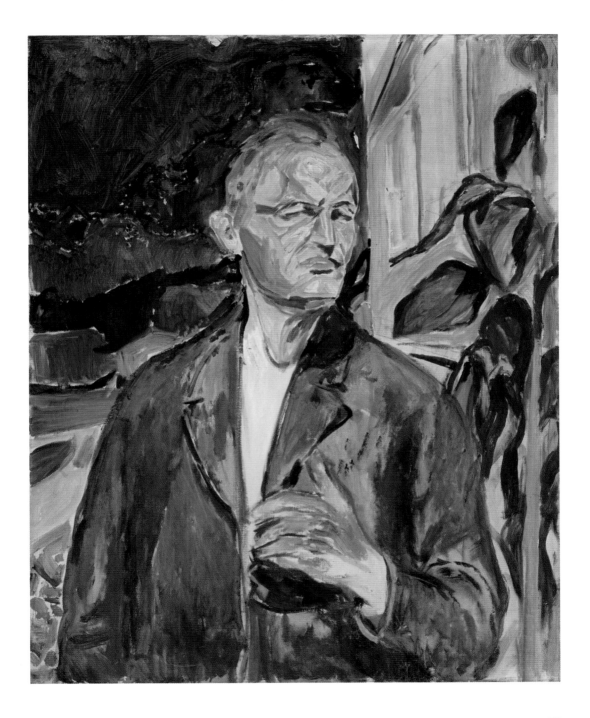

62
*Self-Portrait Between the
Clock and the Bed* 1940–3
Oil on canvas
149.5 × 120.5
Munch Museum

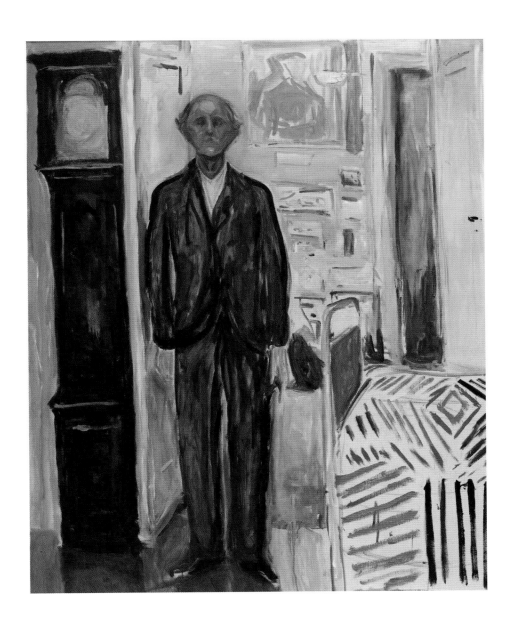

Notes

1. Oskar Kokoschka, 'Munch's Expressionism', *College Art Journal,* vol.13, no.1, 1953.

2. For a comprehensive biography of the man, see Atle Næss, *Munch: En biografi,* Oslo 2004. (French edition 2011.) See also Reinhold Heller, *Munch. His Life and Work*, Chicago 1984.

3. Munch's poetic description of 'The Frieze of Life' in his booklet LIVSFRISEN, 1919.

4. Clement Greenberg, 'Complaints of an Art Critic', 1967, in *The Collected Essays and Criticism, Volume 4, Modernism with a Vengeance, 1957–1969,* ed. John O'Brian, Chicago and London 1993.

5. T 2759, p.14, Edvard Munch's Writings, Munch Museum (hereafter MM).

6. Their five different addresses in Grünerløkka still exist, as does Pilestredet 30.

7. T 2734, p.2, MM.

8. T 2785, p.125, MM.

9. *The Death of the Bohemian* (mid-1920s) relates to Hans Jæger's death in 1910. A lithographic portrait of Jæger was among the last things Munch produced in late 1944. See Frank Høifødt, 'The Kristiania Bohemia reflected in the art of the young Edvard Munch', in Erik Mørstad (ed.), *Edvard Munch: An Anthology*, Oslo 2006.

10. Munch's texts are now largely digitised. www.emunch.no

11. There was no art academy in Norway at the time. Artists with ambitions had to complete their training abroad, and by the late 1880s, Paris was the natural destination.

12. From the so-called *Saint-Cloud Manifesto,* N 289 (1889–90), MM.

13. Andreas Aubert, 'Høstudstillingen IV. Edvard Munch', *Dagbladet,* 5 November 1890. See Heller 1984, p.69.

14. Christian Krohg, 'Den gule båten', *Dagbladet,* 27 November 1891.

15. Scholars disagree on the identity of the original painting, which may be lost. See Gerd Woll, *Edvard Munch: Complete Paintings,* vol.1, London and New York 2008, p.267.

16. T 127-39R, MM.

17. Related by colleague Christian Skredsvig, Munch's travel companion and host in Nice.

18. *Berliner Tageblatt,* 8 November 1892. See *Munch und Deutschland,* exh. cat., Hamburger Kunsthalle, Hamburg 1994, p.83.

19. On account of the 'Munch Affair', a latent tension between conservative and liberal members of the Berlin Artists' Association flared into open conflict, preparing the ground for a schism and the establishment of the Berlin Secession.

20. MM N 30

21. Stanislaw Przybyszewski (ed.), *Das Werk des Edvard Munch: Vier Beiträge,* Berlin 1894.

22. In 1918, Munch exhibited a monumental version of the motif, using the neutral title *Woman Kissing a Man on the Neck.*

23. From the minutes of the Norwegian Students' Society, meeting on 9 November 1895.

24. N 314, MM.

25. August Strindberg, 'L'Exposition d'Edvard Munch', *La Revue Blanche,* 1 June 1896, p.525.

26. See 'Fifty years of printmaking', in Gerd Woll, *Edvard Munch: The Complete Graphic Works,* Oslo 2002.

27. T 27-03-13 (M&F, p. 212/281), MM.

28. N 29, MM.

29. Edvard Munch: LIVSFRISEN, 1919.

30. 'In my desperation I have found now that it might set your mind at ease if we were at least formally married,' Munch wrote to Tulla Larsen in October/November 1899. Letter draft, C 11, MM.

31. Julius Meier-Graefe, 'Beiträge zu einer modernen Aesthetik. Der Einfluss Millets', *Die Insel,* no.1, vols.3–4, Munich 1900, p.215.

32. For more on this connection, see Frank Høifødt, 'Style and Theme around 1900', in Klaus Albrecht Schröder (ed.), *Edvard Munch: Theme and Variation,* exh. cat., Albertina, Vienna 2003.

33. The painting was praised by his Berlin colleagues, and Munch made more than a dozen versions of the subject.

34. Max Linde, *Edvard Munch und die Kunst der Zukunft,* Berlin 1902.

35. Gustav Schiefler, *Verzeichnis des graphischen Werks Edvard Munch,* vol.1, Berlin 1907, vol.2, Berlin 1928. (Facsimile edition, Oslo 1974.)

36. See Arne Eggum, 'Munch et le fauvism', in *Munch et la France,* exh. cat., Musée d'Orsay, Paris 1991.

37. Two literary personages associated with the Bohemian milieu – Gunnar Heiberg and Sigurd Bødtker.

38. It seems Munch had not been sufficiently attentive to Dr Linde's requests; the frieze contained subjects considered inappropriate for a child's intimate environment. Dr Linde soon compensated Munch's economic loss by paying the agreed amount for another painting, *Women on the Bridge.*

39. Atle Næss 2004, p.365.

40. See Arne Eggum, *Portretter,* exh. cat., Munch Museum, Oslo 1994, p.6.

41. Exact location and date is hard to ascertain for many paintings from these years, as Munch bought and rented several houses and estates.

42. After refurbishing the hall and cleaning and consolidating Munch's wall paintings, the Aula was re-inaugurated in 2011, attracting new popular and scholarly interest. See *Munch's Laboratory: The Path to the Aula,* exh. cat., Munch Museum, Oslo 2011.

43. He still had Hvitsten, and in 1918 acquired another estate for a shorter period.

44. See Elisabeth Prelinger, *After the Scream: The Late Paintings of Edvard Munch,* exh. cat., High Museum of Art, New Haven 2001.

45. See Gerd Woll, 'From the Aula to the City Hall: Edvard Munch's Monumental Projects 1909–1930', in *Edvard Munch: Monumental Projects 1909–1930,* exh. cat., Lillehammer Art Museum, Lillehammer 1993.

46. See Iris Müller-Westermann, *Munch by Himself,* London 2005.

Index

First published 2012 by order of the Tate Trustees
by Tate Publishing, a division of Tate Enterprises
Ltd, Millbank, London SW1P 4RG
www.tate.org.uk/publishing

© Tate 2012

A catalogue record for this book is available from
the British Library

ISBN 978 1 84976 022 5

Distributed in the United States and Canada by
ABRAMS, New York

Library of Congress Control Number: 2011940887

Designed by Anne Odling-Smee, O-SB Design
Colour reproduction by DL Interactive Ltd, London
Printed and bound in China by C&C Offset
Printing Co., Ltd

Front cover: Edvard Munch, *Anxiety* 1894,
oil on canvas, 94 × 73, Munch Museum
Frontispiece: Edvard Munch, *Starry Night*
1922–4 (detail of fig.60)

Measurements of artworks are given in
centimetres, height before width.

MIX
Paper from
responsible sources
FSC® C008047

Photo credits

All images copyright the
owner of the work unless
otherwise stated below

Bergen Museum, Rasmus Meyer
 Collection figs.20, 23, 27, 32,
 33, 54
Finnish National Gallery/Central Art
 Archives/Jaakko Holm fig.52
Photo by Sidsel de Jong fig.56
Photo © Kunsthaus Zurich fig.22
© J. Lindegaard fig.2
Lübeck Museum, Germany/ The
 Bridgeman Art Library fig.45
Photo © Munch Museum, Oslo
 Front cover, figs.1, 8–11, 13–15,
 17, 19, 26, 35, 37–40, 46–9, 51,
 53, 55, 57–8, 60–2
Photo courtesy Munch Museum ©
 Kunsthaus Zurich fig.50
Photographer unknown, courtesy
 Munch Museum fig.12
Eirik Urke, Munch Museum, Oslo
 fig.16
Photo by L Børre Høstland,
 Nasjonalmuseet for Kunst,
 Arkitektur og Design/The
National Museum of Art,
 Architecture and Design fig.28
Photo by Jacques Lathion,
 Nasjonalmuseet for Kunst,
 Arkitektur og Design/The
National Museum of Art,
 Architecture and Design
 figs.3–6, 24–5, 36, 43, 59
© The National Museum, Oslo
 figs.30, 31, 34, 41, 44
The J. Paul Getty Museum, Los
 Angeles fig.29

Copyright credits

Edvard Munch © Munch Museum/
Munch-Ellingsen Group/ DACS,
London 2012

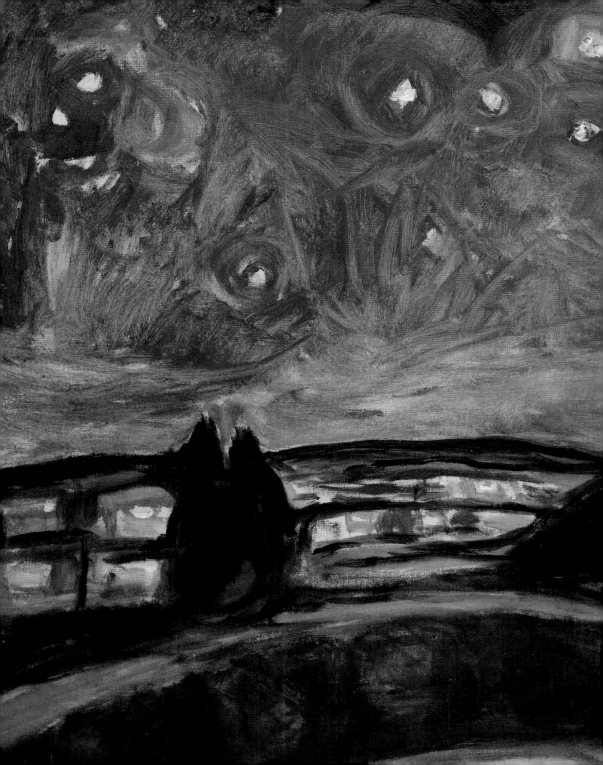

Edvard Munch